THE GROHMANN MUSEUM
AT MILWAUKEE SCHOOL OF ENGINEERING

MSOE Press, Milwaukee, Wisconsin

The Grohmann Museum at Milwaukee School of Engineering
1000 North Broadway, Milwaukee, Wisconsin

Fourth Edition
©2014 Milwaukee School of Engineering. All rights reserved.

Publisher: Milwaukee School of Engineering
 1025 North Broadway
 Milwaukee, Wisconsin 53202, USA
 (414) 277-7138
 www.msoe.edu

ISBN 978-0-9728044-5-5

CONTENTS

INTRODUCTION

The opening of the Grohmann Museum is the end of one era and the beginning of another. For Dr. Eckhart G. Grohmann it is the first time that his *Man at Work* Collection is largely under one roof. In his 40 or so years of assembling the collection it has been divided between his home and several companies with which he has been associated.

It has been Dr. Grohmann's desire that the *Man at Work* Collection should be united and displayed in a way that builds on the collection as a whole and leverages the scale and breadth of the collection to present a clear image of the honor of work. The importance of the whole collection is certainly much greater than the sum of the parts. Here at Milwaukee School of Engineering the collection will remain intact and be of major importance to the university for many years to come. This is particularly true because Dr. Grohmann's collection is so important to all of us since it represents the origin and evolution of the very subjects we teach today. It is truly a perfect match of art and institution.

By his efforts to find the collection a worthy new home, Dr. Grohmann has done a wonderful thing. He has created a masterpiece building to house his masterful collection. The collection and building together elevate each other beyond what either would be by itself. It was Dr. Grohmann's vision that this would happen, and it clearly has.

The building evolved with the effort and cooperation of many individuals, but the force behind it was and is Dr. Eckhart Grohmann. The basic European inspiration for the museum came from him. The extraordinary features of the building were influenced by several other individuals, but were nevertheless Dr. Grohmann's basic vision. They all build upon the dramatic architecture and the extraordinary giant bronze statues, the stained glass windows, the Roman-style mosaic tile floor and the ceiling painting. They all focus upon his concept of honoring hard work and the people who do it.

On behalf of the Milwaukee School of Engineering students, faculty and staff, and on behalf of anyone who respects the concept of hard work – let us honor Dr. Eckhart Grohmann. He has worked so diligently to make this museum reality and now, to his great credit and our everlasting debt, it is here for us all to enjoy.

Thank you, Dr. Grohmann.

Hermann Viets, Ph.D.
President
Milwaukee School of Engineering

THE GROHMANN MUSEUM

The Grohmann Museum is named in honor of Dr. ⸱khart Grohmann, an MSOE Regent, Milwaukee ᵤsinessman and avid art collector, who donated this ⸱llection to MSOE in 2001 and subsequently the ᵤnds to purchase, renovate and operate the museum ⸱at bears his name.

⸱r. Grohmann and his wife, Ischi, are longtime ᵤpporters of scholarships for MSOE students and ⸱nated funds to purchase the property for the Kern ⸱enter, MSOE's health and wellness facility that ⸱ened in 2004.

To understand this unique collection, it is helpful ⸱ have some background on the collector, who grew ⸱ visiting his grandfather's large marble processing ᵤsiness and quarry operation in Silesia, Germany ⸱ow within the borders of Poland). It was there, ⸱atching the stonecutters and sculptors select raw ⸱aterial that would soon become a work of art, that ⸱rohmann developed his appreciation and ⸱lmiration of work. To Grohmann, hard work is not ⸱ idealized concept but a principle of life.

⸱ Grohmann was chairman and president of ⸱ilwaukee's Aluminum Casting & Engineering Co., ⸱rm he acquired in 1965 and grew from a small ⸱undry of 35 employees to a company ten times that ⸱ze. It makes high-volume aluminum components ⸱r the automotive industry. A successful ⸱trepreneur, Grohmann co-founded Central ⸱ontrol Alarm Corp. in 1980 and developed it into ⸱e leading alarm company in Wisconsin before ⸱lling it to Ameritech in 1997.

⸱ He earned a Diplom Kaufmann (MBA) from the ⸱niversity of Mannheim in 1962 and received an ⸱norary Doctor of Engineering degree from MSOE ⸱ 1999. Dr. Grohmann has served as an MSOE ⸱orporation member since 1974 and Regent since ⸱90. He has been collecting works of art since the ⸱60s.

Eckhart and Ischi Grohmann

In discussing his gift of the art collection to MSOE, Dr. Grohmann identified the similarity between the evolution of work and the pragmatic educational approach of this university. While a museum setting would be expected, a university setting provides students, staff and visitors with a historical context for their own activities as they relate to engineering and business. The value of art to the students is dramatic.

"Exposure to this collection will help open students' eyes to the historical evolution of work from its early, modest beginnings and allow them to better understand the roots of today's production processes," said Grohmann.

The integration of art into the various curricula at MSOE has had a profound influence on students and will for generations to come.

INTEGRATING ART AND ARCHITECTURE

THE BUILDING

The Grohmann Museum *Man at Work* Collection of industrial art is the most comprehensive in the world. As such, it begs to be housed in an appropriate setting. Rather than in the original plan to use the German-English Academy building next door, this more ideal location became available. With Dr. Grohmann's generous support,

MSOE acquired the building in mid-2005. The structure originally served as home to several automobile dealerships, including Metropolitan Cadillac. In the 1970s the building received a new exterior and was leased and later sold to the Federal Reserve Bank of Chicago as a check-processing center. The appearance of the building in early 2005 is shown below.

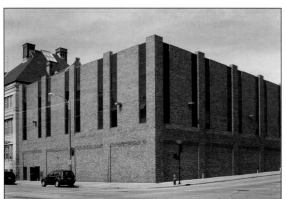

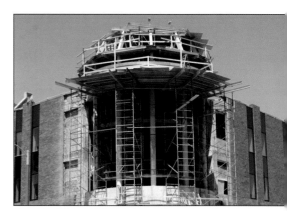

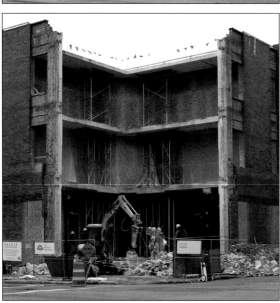

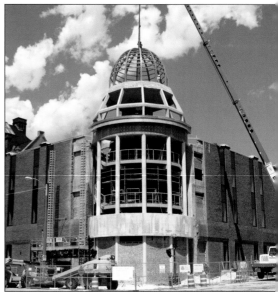

Construction process.

resembled a fortress, as appropriate for its
anking function.

To serve as a museum to display the *Man at Work*
ollection, the building needed a more inviting
xterior. The new design replaces the corner of the
uilding with a 32-foot diameter glass cylinder,
ontaining the atrium and main staircase. The glass
rium is alive with activity as visitors go from floor
floor. This activity behind a glass surface echoes
e design of MSOE's Kern Center at the other end
the MSOE campus on Broadway. These two
uildings will serve as glass bookends for this north-
uth element of the campus.

The museum's steel and glass-domed entrance
elcomes visitors to three floors of gallery space
here the core collection is displayed as well as
casional special themed exhibitions. The
useum also has a spectacular rooftop sculpture
rden, penthouse, auditorium, docent library,
ft shop, vending cafe and workshop.

THE ATRIUM

Greeted by stunning architectural elements that
have been inspired by the collection, visitors are
introduced to many important themes from
the collection as they enter the glass and steel
domed atrium.

German artist Hans Dieter Tylle used images
from existing art works to capture the theme,
diversity and quality of the collection and
incorporated those into new works of his creation
that now adorn the structure itself. As visitors cross
the threshold, they are greeted by workers in a
Roman-style mosaic tile floor. High above their
heads, *Vulcans Forge* and great thinkers from history
greet the visitor in a semi-Impressionist mural on
the ceiling. In the upper section of the domed
atrium workers are again incorporated
into the stained glass windows that – by virtue
of their translucence – convey the sense of the
collection to the outside and inside worlds.

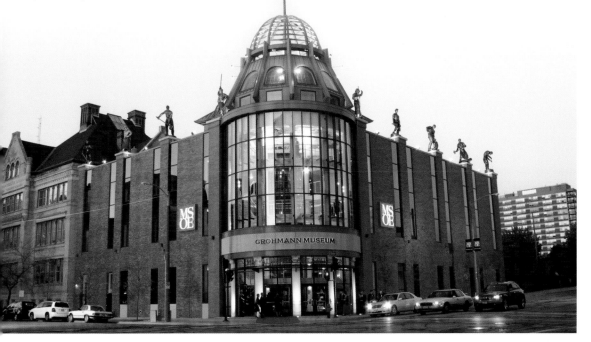

FLOOR MOSAIC

FLOOR MOSAIC IS A WARM, COLORFUL WELCOME

Used to express religion, culture or simply as decoration, mosaics have been an impressive element of interior and exterior art since ancient times. For example, a popular mosaic during the Roman era was the "cave canem" (beware of the dog) mosaic found just inside the threshold of villas. Drawing on this tradition, the Grohmann Museum has a magnificent mosaic in its glass entryway, but it signifies a warm welcome rather than a warning.

Designed by German artist H. D. Tylle and created by

the "Mayersche Hofkunstanstalt" in Munich, Germany, the mosaic draws upon images from the collection and features five images of men and women at work. Emphasizing manual labor, Tylle chose the miner, spinner, fieldworker, blacksmith and foundry worker to represent various aspects of the collection. As a medium for the initial composition he created oil paintings measuring 24 x 32 inches. On the positioning of the figures comes from th original paintings, while the light and the skin tones have

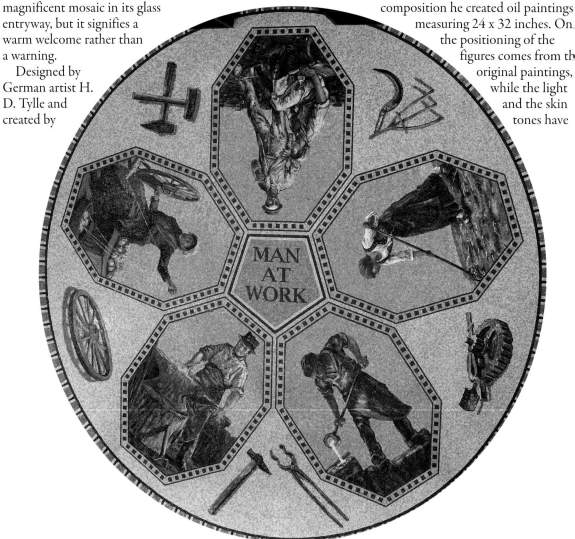

FLOOR MOSAIC

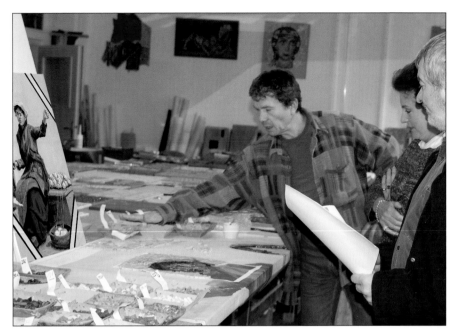

en transformed by
ylle into the style for
hich he is known. By
e nuanced sense of
lor employed by the
tists at "Mayersche
ofkunstanstalt"
Herbert Hahn, Hans
erkommer, Franco
otonica, Tobias Tlusti,
lvia Tulissi), the artist's
udy paintings were
anslated into the classic
osaic form.

Herbert Hahn explains the transposition of Tylle's oil painting into the mosaic to Ischi Grohmann and H.D. Tylle.

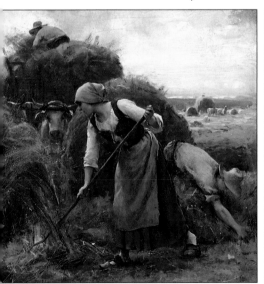

ages from the collection, such as those found in Julien Dupré's *The Hay Harvesters* (detail left) were inspiration for the mosaic.
own from above while in process (right), this figure is surrounded by boxes of color tiles from which the artist chooses.

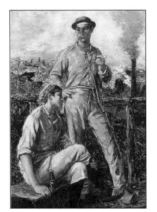

Constantin-Emile Meunier
(Belgian, 1831-1905), *The
Miners*, oil on canvas.

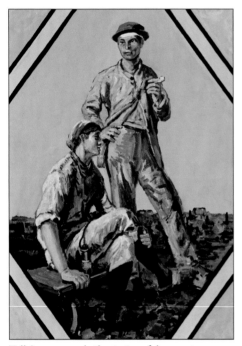

Tylle's conceptual oil painting of the mosaic.

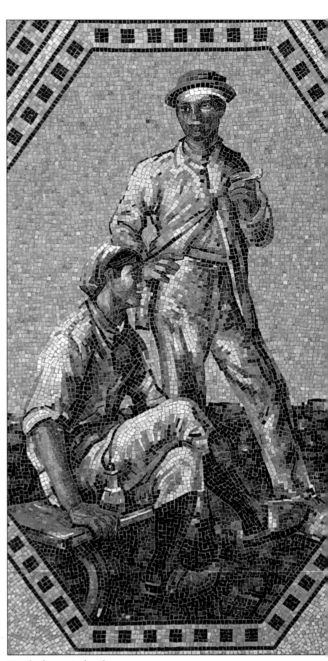

Finished mosaic detail.

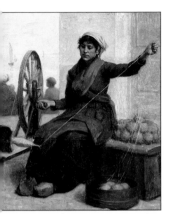

ugene Feyen (French, 1815-1908),
he Breton Spinner, oil on panel.

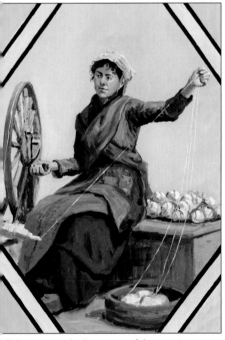

ylle's conceptual oil painting of the mosaic.

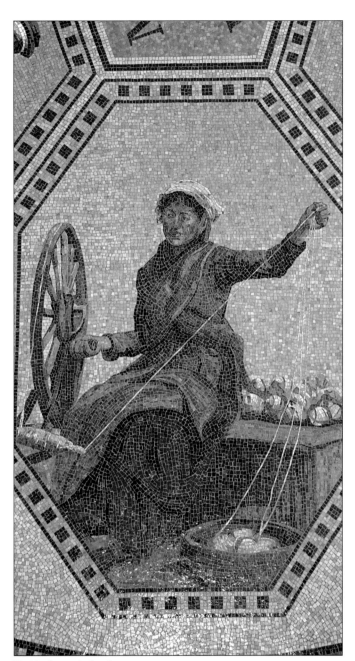

Finished mosaic detail.

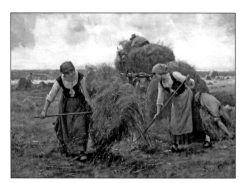

Julien Dupré (French, 1851-1910), *The Hay Harvesters*, oil on canvas.

Tylle's conceptual oil painting of the mosaic.

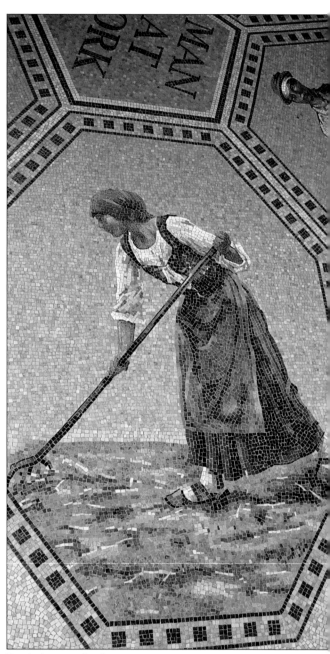

Finished mosaic detail.

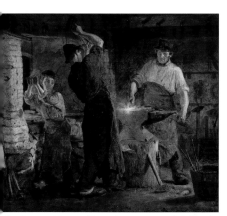

der Severin Kroyer (Danish, 1851-1909), *Three niths at Hornbaek, Denmark,* 1877, oil on canvas.

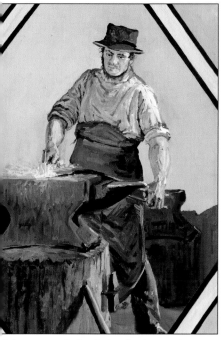

lle's conceptual oil painting for the mosaic.

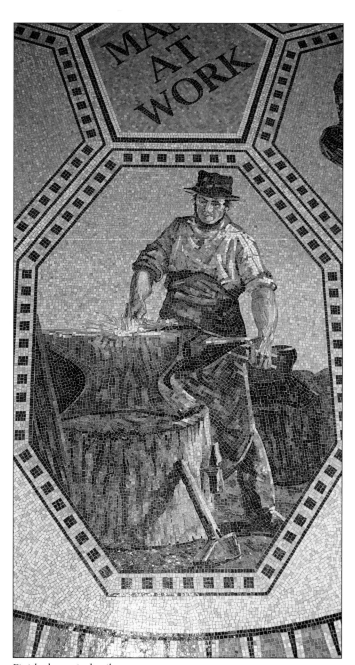

Finished mosaic detail.

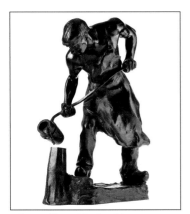

John Wolfgang Elischer (Austrian, act. 1920-1930), *Foundryman*, cast iron.

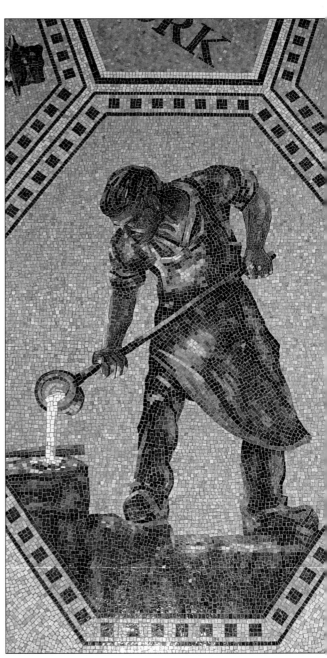

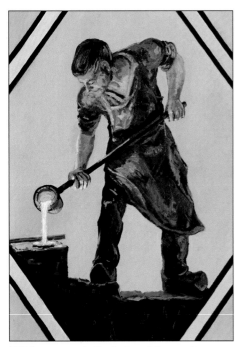

Tylle's conceptual oil painting of the mosaic.

Finished mosaic detail.

CEILING MURAL

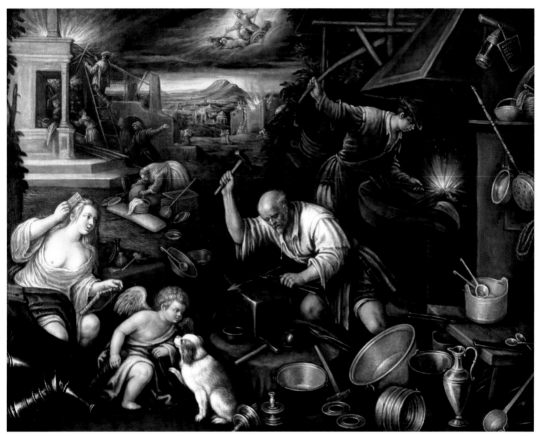

Francesco Bassano's *Vulcan's Forge* was the inspiration for Tylle's ceiling mural.

The atrium's ceiling features a 700-square-foot rcular mural inspired by the collection's painting picting Venus and Cupid at the Forge of Vulcan. This very early representation of blacksmithing is at of the God Vulcan, who forges arrows for his n, Cupid, while his wife, Venus, watches. The scene repeated in several paintings in the collection. lle's inspiration is a painting from the 1580s: *lcan's Forge*, by a student of the Italian painter ancesco Bassano [1559-1592].

In the mural, Tylle portrays the worlds of the gods and the inventive human spirit in juxtaposition to the manual laborers of the mosaic tile floor below. His belief that the industrial development of humankind was — and is — only possible through the curiosity, perseverance and endless desire for scientific knowledge is represented by Johannes Gutenberg, Leonardo da Vinci, Thomas Edison, Marie Curie and Albert Einstein.

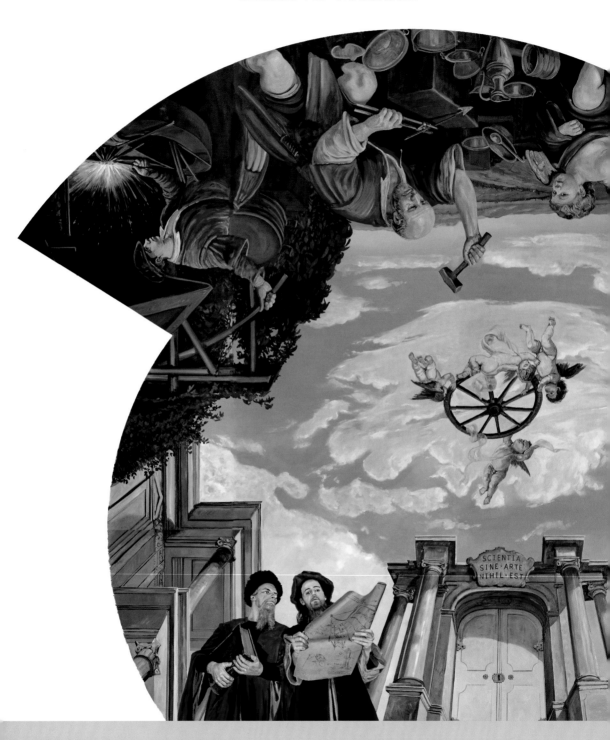

The presence of these technological giants also suggests the special role of the art collection at MSOE. Enriched with knowledge, students will travel through the gate into their future. The inscription CARPE DIEM ("Seize the day") reminds us all that their time as a student is valuable. The quote from a 14th century architect SCIENTIA SINE ARTE NIHIL EST ("Science without art is nothing") emphasizes the quality of the education at MSOE.

Tylle used live models for the figures of great thinkers, achieving a particularly intense portraiture. Furthermore, he borrowed costumes for his models from the Kassel Staatstheater to heighten the realism of the portraits. In the center of the painting is one of the greatest and most important engineering feats of human history: the wheel.

Vulcan's Forge and Great Minds of History
Oil on board, 275 x 320 in., 2006/2007

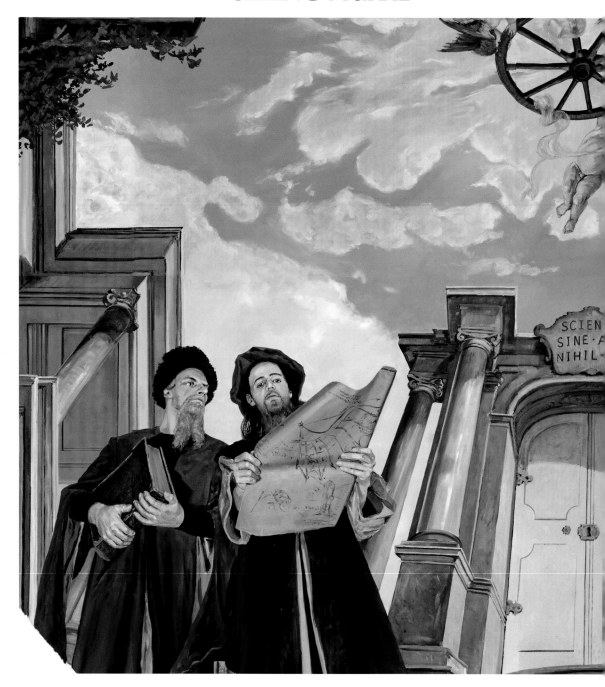

il from: *Vulcan's Forge and Great Minds of History*, Oil on board, 275 x 320 in., 2006/2007

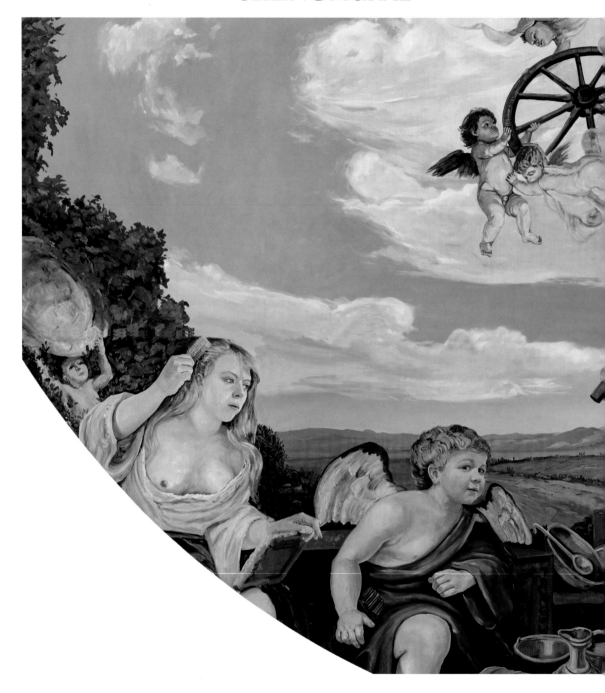

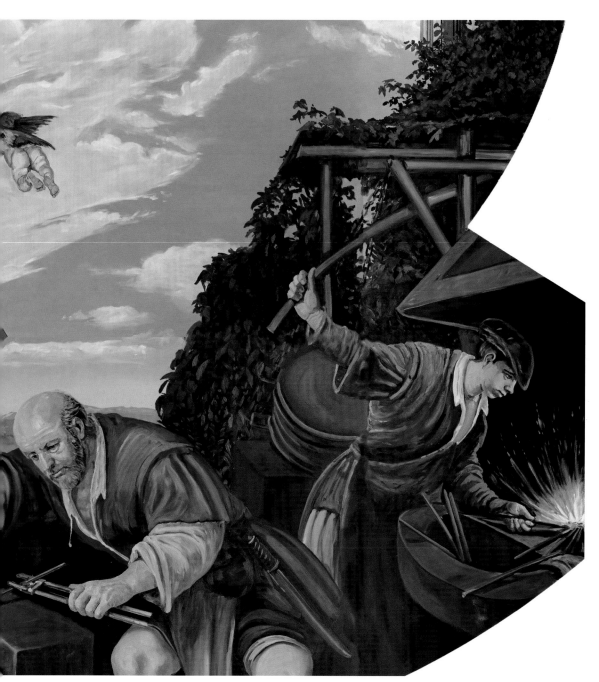

Detail from: *Vulcan's Forge and Great Minds of History*, Oil on board, 275 x 320 in., 2006/2007

CEILING MURAL

Tylle at work in his studio in Kassel, Germany.

Tylle used live models to capture intense portraiture.

The mural, oil on wood panel, was installed in sections.

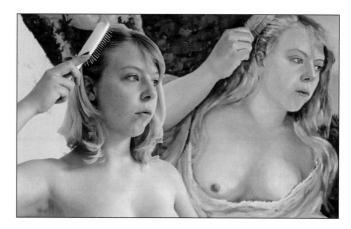

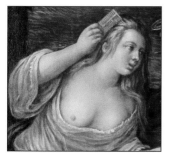

Venus from the painting *Vulcan's Forge* by a Student of Italian Painter Francesco Bassona (1559-1592), oil on canvas.

Vulcan from the painting *Vulcan's Forge* by a Student of Italian Painter Francesco Bassona (1559-1592), oil on canvas.

Cupid from the painting *Vulcan's Forge* by a Student of Italian Painter Francesco Bassona (1559-1592), oil on canvas.

Models pose for Venus, Vulcan and Cupid at Tylle's studio in Kassel, Germany.

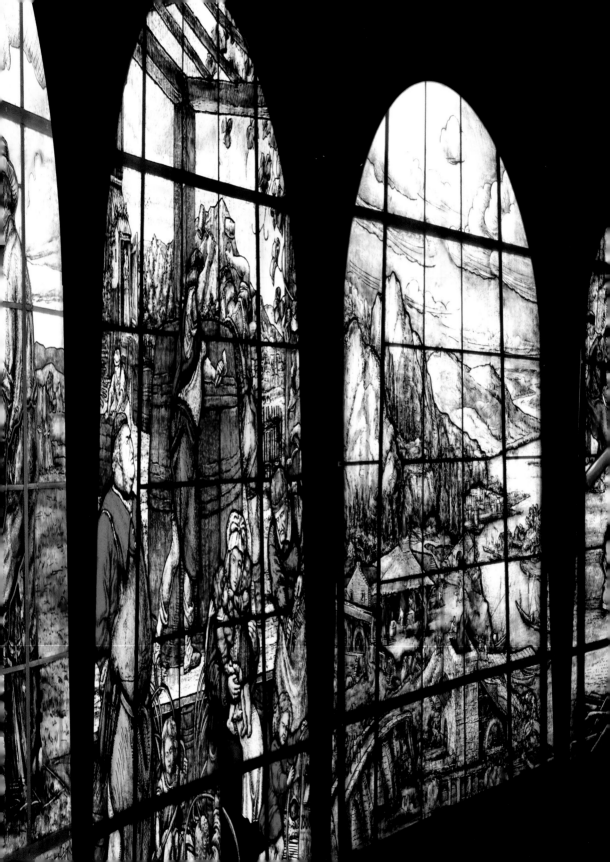

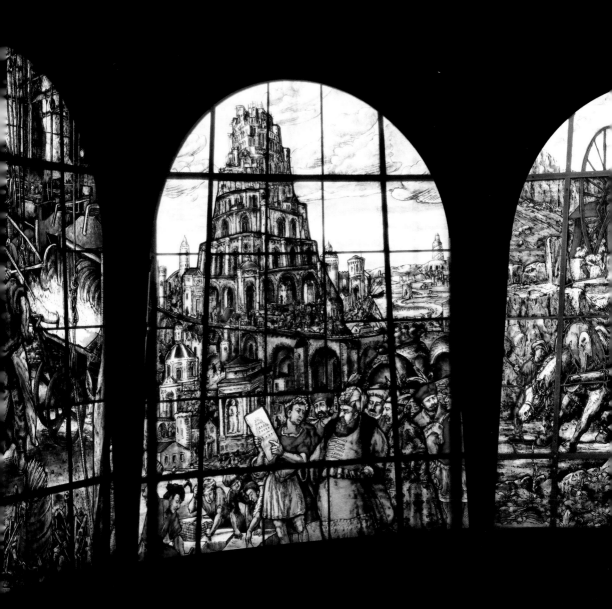

STAINED GLASS

GLASS PRESENTS ENLIGHTENED VIEW OF WORK

In September 2006, H.D. Tylle was commissioned to create eight stained-glass windows (measuring 88 x 64 inches) for the dome of the new Grohmann Museum. The subjects for the works were selected from the *Man at Work* Collection. The windows depict workers at a river valley iron smelter, the construction of the Tower of Babel as well as men and women working at a steel rolling mill, hay harvesters, blacksmith, carpenter, cooper and quarryman.

H.D. Tylle developed a compositional grid for each window, selected details from the original paintings and created his own artwork appropriate for the medium of stained glass.

First, he completed eight ink and watercolor sketches of the proposed compositions, capturing the coloring effect of stained glass. The next challenge was developing an ink drawing that would be transferred onto the glass. Tylle completed these drawings in full scale in his studio in Kassel, Germany.

The windows were produced by the "Mayersche Hofkunstanstalt" in Munich, Germany. There the drawings were silk-screen printed on the glass and colored by the glass-painter Marcela Großhauser in close collaboration with Tylle. The glass was then framed in lead and soldered into place.

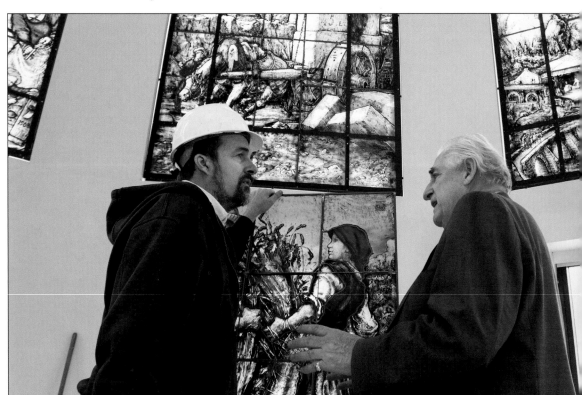

Dr. Grohmann (right) discusses the installation of the stained glass with Paul Phelps of Oakbrook Esser Studio, Oconomowoc, Wis.

STAINED GLASS

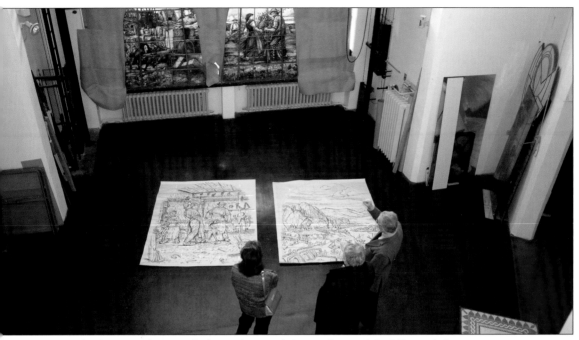

hi Grohmann, Gabriel Mayer and H.D. Tylle discuss the stained glass windows and the full size ink drawings.

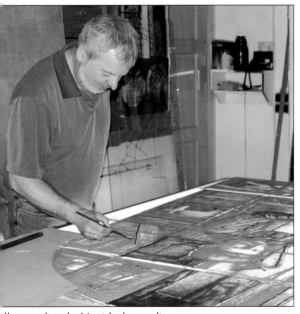

lle at work at the Munich glass studios.

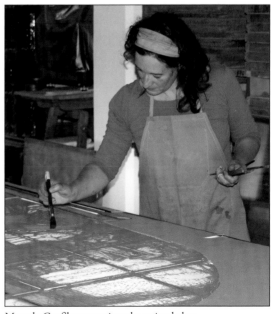

Marcela Großhauser paints the stained glass.

STAINED GLASS

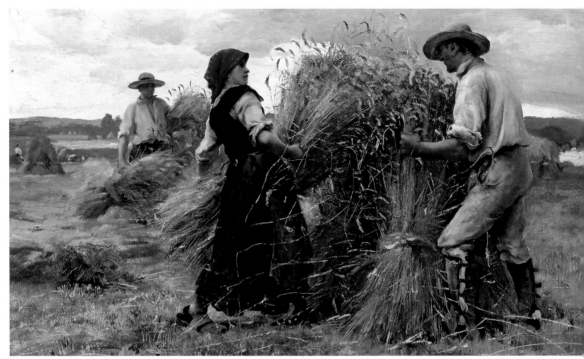

Julien Dupré (French, 1851-1910), *Stacking Grain Sheaves,* oil on canvas, 20 1/2 x 25 1/4 in.

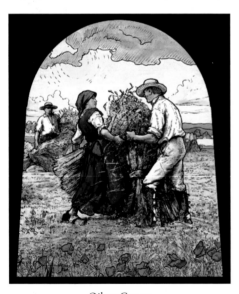

Oil on Canvas

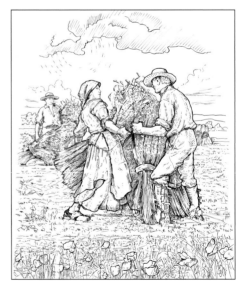

Ink Drawing

STAINED GLASS

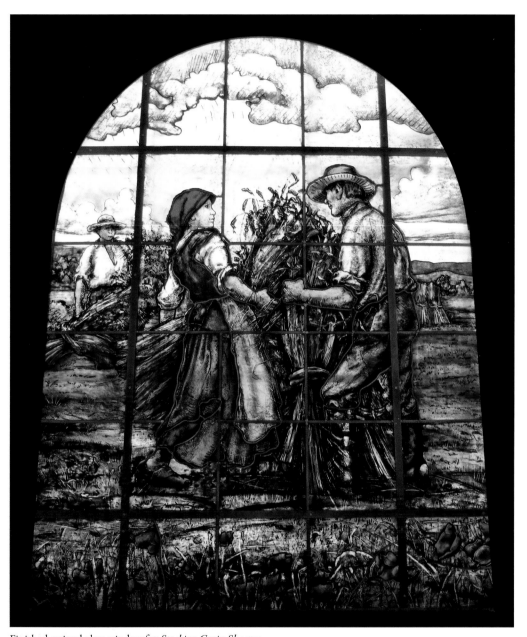

Finished stained glass window for *Stacking Grain Sheaves*.

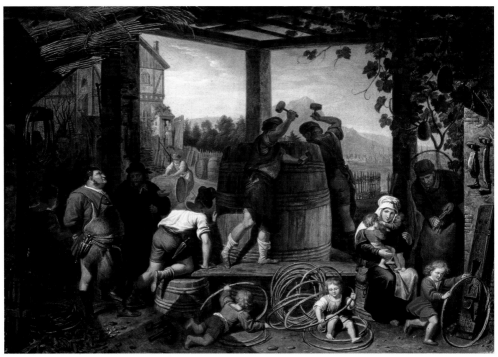

Carl Wilhelm Kolbe (German, 1781-1853), *Cooper Shop*, ca. 1816, oil on panel, 16 3/4 x 21 3/4 in.

Oil on Canvas

Ink Drawing

STAINED GLASS

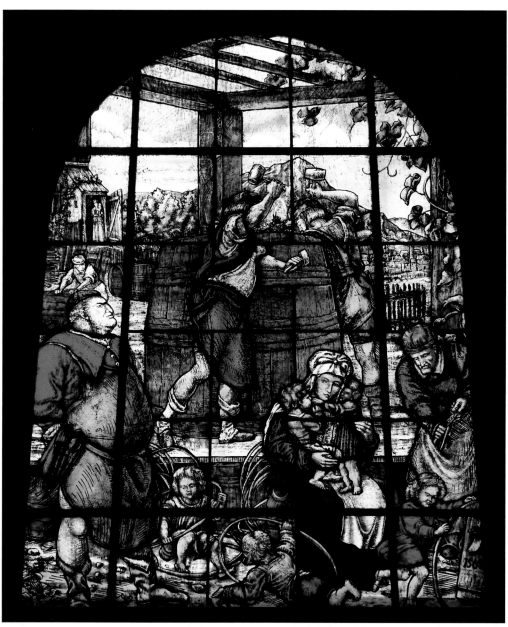

Finished stained glass window for *Cooper Shop*.

STAINED GLASS

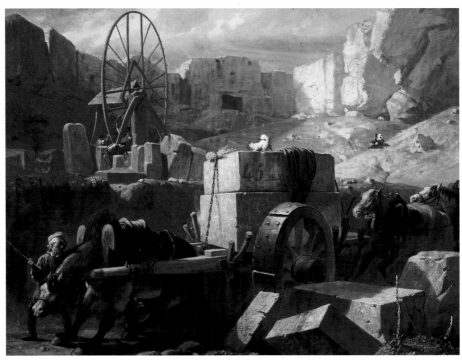

Wouter Vershuur (Dutch, 1812-1874), *Quarry,* 1853, oil on canvas, 51 1/4 x 64 in.

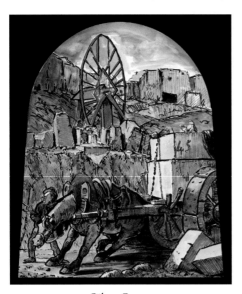

Oil on Canvas

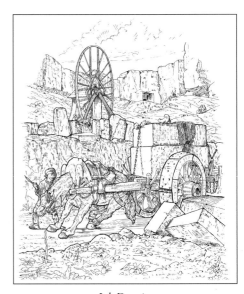

Ink Drawing

STAINED GLASS

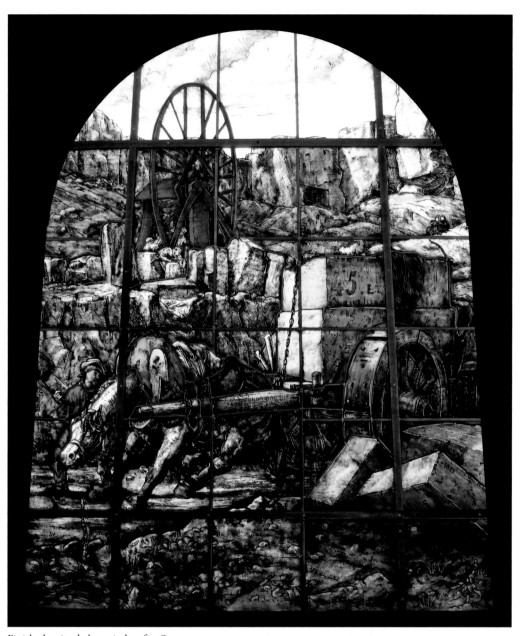

Finished stained glass window for *Quarry*.

STAINED GLASS

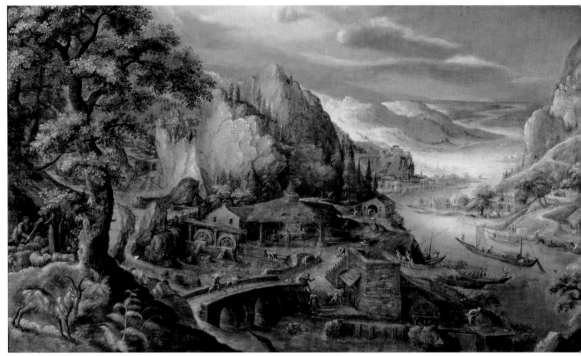

Marten van Valckenborch (Flemish, 1535-1612), *A River Valley with Iron Smelter*, ca. 1600, oil on canvas, 29 x 44 3/4 in.

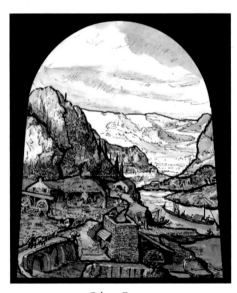

Oil on Canvas

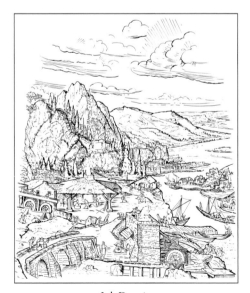

Ink Drawing

STAINED GLASS

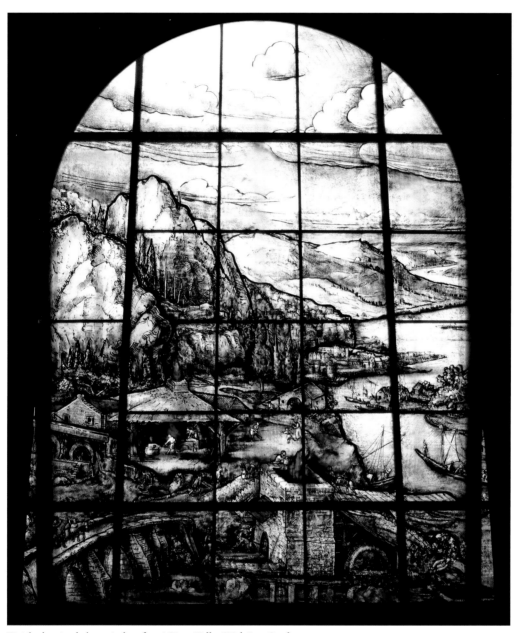

Finished stained glass window for *A River Valley With Iron Smelter.*

STAINED GLASS

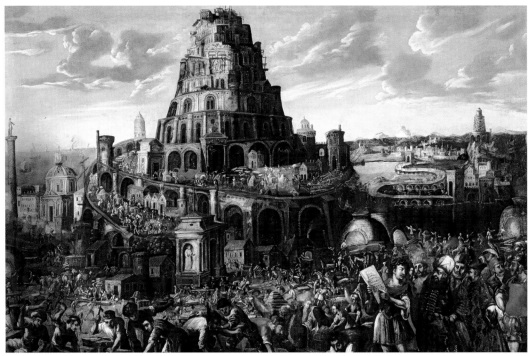

Circle of Gillis van Valckenborch (Flemish, 1560-1622), *The Tower of Babel*, oil on canvas, 44 1/4 x 65 in.

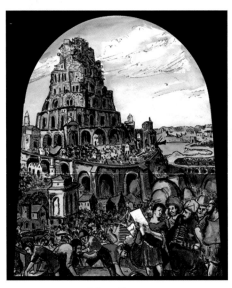

Oil on Canvas

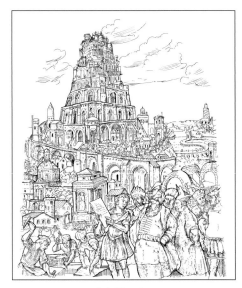

Ink Drawing

STAINED GLASS

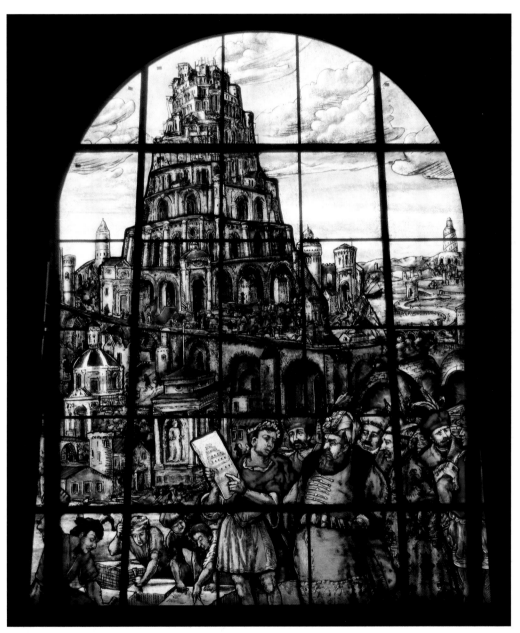

Finished stained glass window for *The Tower of Babel*.

STAINED GLASS

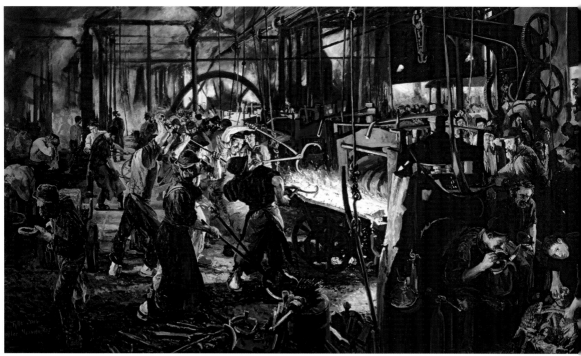

H.D. Tylle (German, b. 1954), after Adolph Menzel, *Iron Rolling Mill*, 2004, oil on canvas, 62 1/2 x 100 1/4 in.

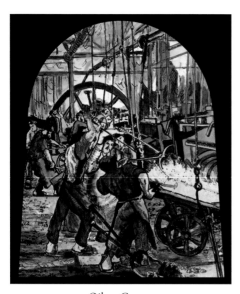

Oil on Canvas

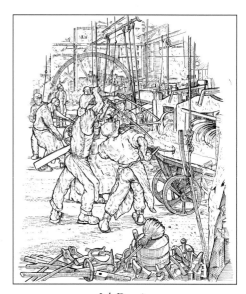

Ink Drawing

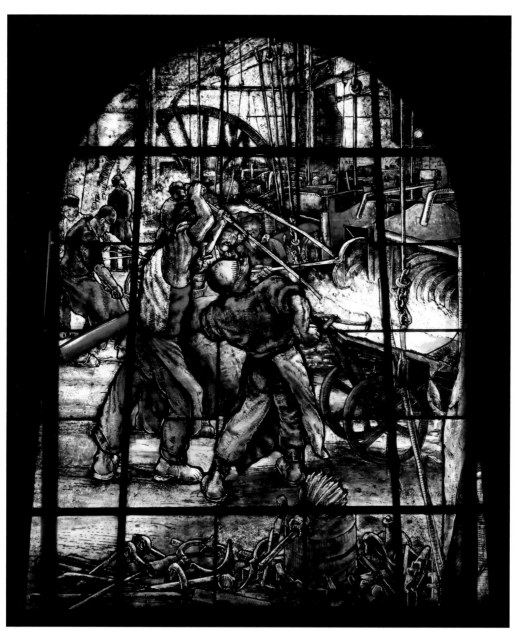

Finished stained glass window for *Iron Rolling Mill.*

STAINED GLASS

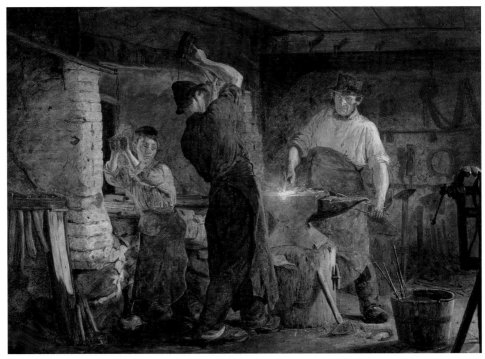

Peder Severin Kroyer (Danish, 1851-1909), *Three Smiths at Hornbaek, Denmark,* 1877, oil on canvas, 37 x 46 in.

Oil on Canvas

Ink Drawing

STAINED GLASS

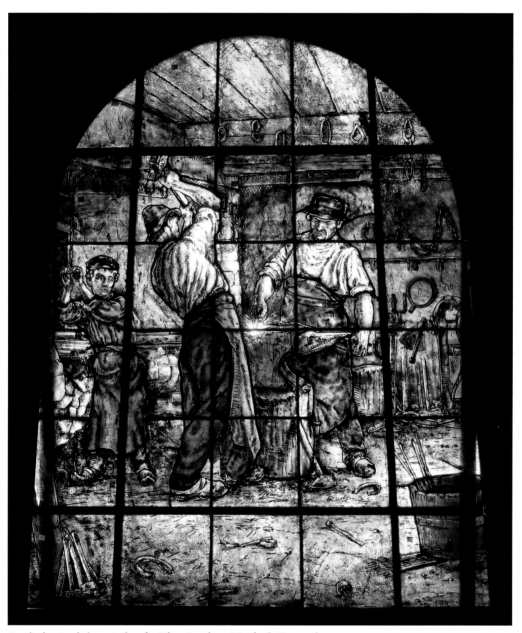

Finished stained glass window for *Three Smiths at Hornbaek, Denmark.*

STAINED GLASS

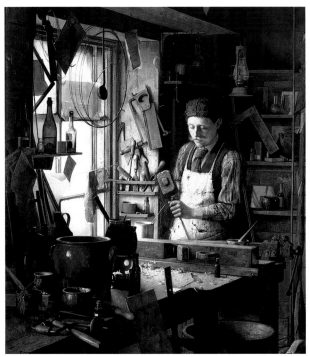

Walter Dexter (British, 1876-1958), *The Carpenter's Workshop*, 1904, oil on canvas, 30 1/4 x 25 1/4 in.

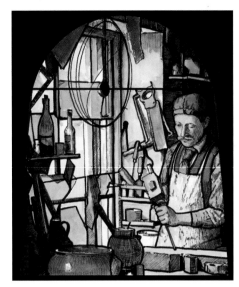

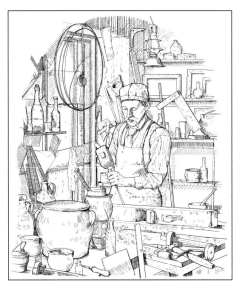

Oil on Canvas Ink Drawing

STAINED GLASS

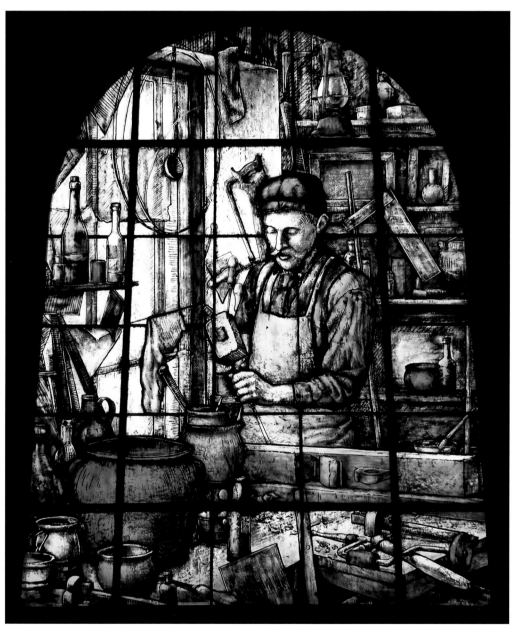

Finished stained glass window for *The Carpenter's Workshop.*

BRONZE SCULPTURES

A BOLD STATEMENT OF STATURE

Sculptures of men toiling in the field and foundry are among the most striking in the *Man at Work* Collection. They also serve as a striking architectural element of the new Grohmann Museum through larger-than-life statues perched on the roofline of the enhanced building.

The German art foundry, Karl Herbich, at the Bavarian town of Gernlinden near Munich, Germany, maintains a workshop at Cebu in the Philippines. It was commissioned to create 12 colossi – 9-foot tall bronze statues – for the roofline of the new MSOE museum and five life-size figures for the rooftop sculpture garden.

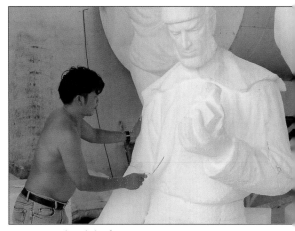

An artist sculpted the foam.

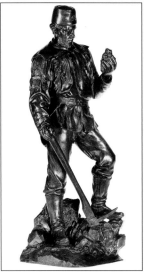

Original 19-inch sculpture.

A skilled sculptor at the Cebu foundry transformed the figures of the existing original artworks between 10-20 inches high into a painstaking exact styrofoam replica of the full-sized finished bronze sculptures.

This one-to-one size foam model serves as the base for the mold construction for the nine-foot finished bronze castings each weighing more than 1,000 pounds. A special silica sand mold holds the negative image of the desired bronze casting and provides for an approximately one-quarter inch wall thickness of the finished piece.

After being poured into the mold, the bronze solidifies and the mold is destroyed to remove the cast part. This rough casting – often only a part of the figure – is finished at the foundry by grinding, polishing and finally applying specific chemicals that

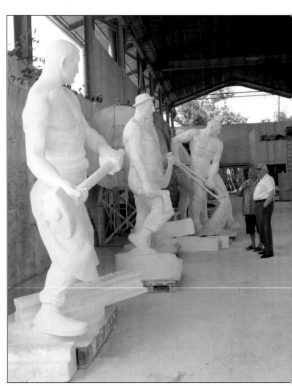

The sculpted foam is ready for a wax coat.

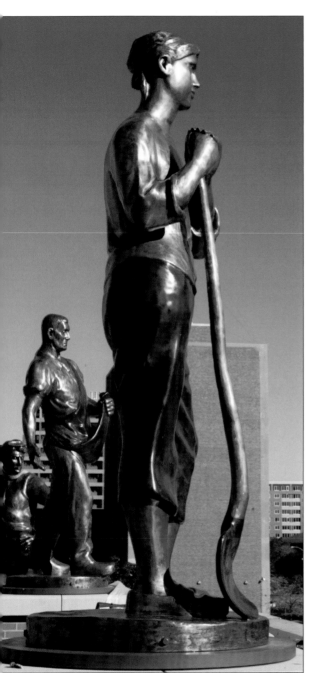

...atues at home on the roof of the Grohmann Museum.

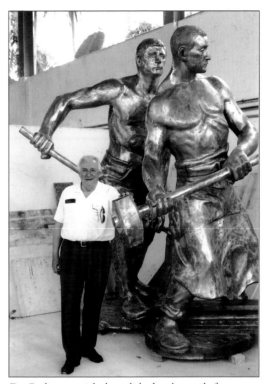

Dr. Grohmann with the polished sculptures before a patina is applied in the next step.

will corrode the metal in a predictable way, creating an attractive finish or patina.

The mammoth sculptures were shipped from Cebu to the MSOE campus. Finally, they were hoisted onto the museum roof by crane, where they overlook the campus and city skyline, calling attention to the content of the museum.

In addition to the 12 large-scale works, six life-size sculptures are displayed in the 10,000 square-foot roof garden. The space is the perfect place for enjoying sculpture, contemplation or entertainment while you – and the bronze workers around you – enjoy a commanding view of a city that was built on the hard work they depict.

LARGE-SCALE BRONZE SCULPTURES

Johann Friedrich Reusch (German, 1843-1906), *Iron Miner from the Siegerland, Germany*

Constantin-Emile Meunier (Belgian, 1831-1905), *Master Forger,* 1890

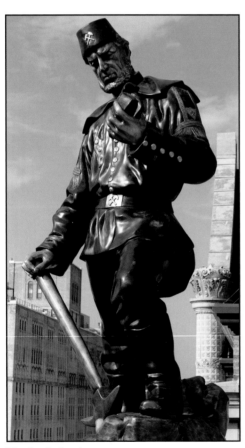

The finished sculpture.

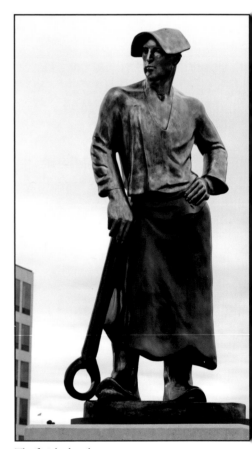

The finished sculpture.

LARGE-SCALE BRONZE SCULPTURES

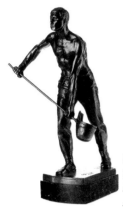

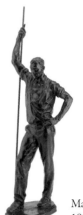

Gerhard Adolf Janensch
(German, 1860-1933),
*Foundry Worker With
Ladle,* 1918

Max Kalish (American,
1891-1945), *The Stoker*

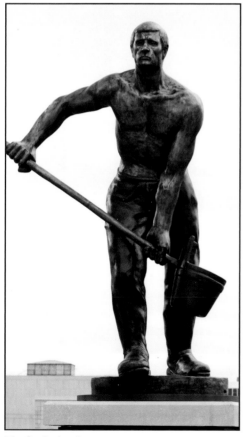

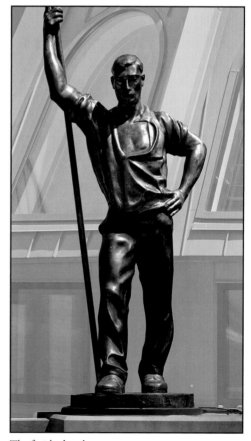

The finished sculpture.

The finished sculpture.

LARGE-SCALE BRONZE SCULPTURES

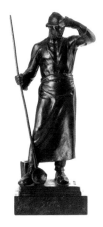

Gerhard Adolf Janensch
(German, 1860-1933),
Steel Worker, 1916

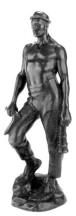

Constantin-Emile Meunier
(Belgian, 1831-1905),
The Old Miner

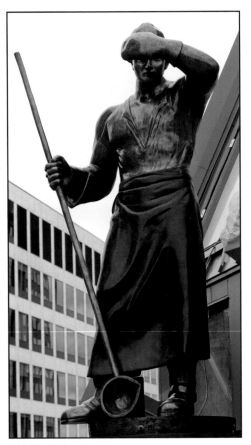

The finished sculpture.

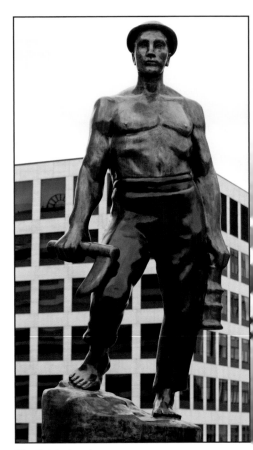

The finished sculpture.

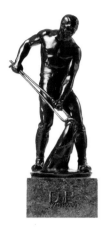

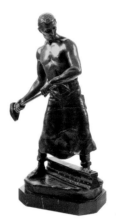

Carl Stock (German, 1876-1945), *Tanner,* 1924

Rudolf Kaesbach (German, 1873-1950), *Railroad Worker*

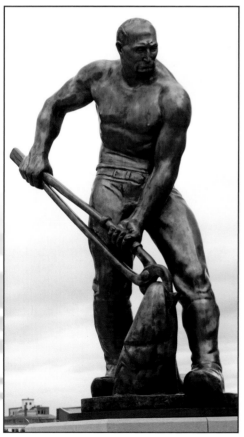

The finished sculpture.

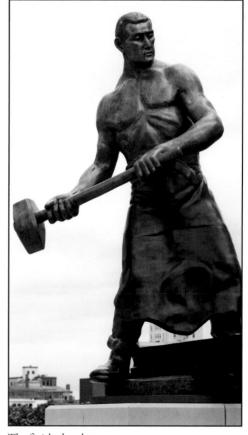

The finished sculpture.

LARGE-SCALE BRONZE SCULPTURES

Unknown Artist,
Glass Blower, 1927

Constantin-Emile
Meunier (Belgian,
1831-1905),
Female Mine Worker

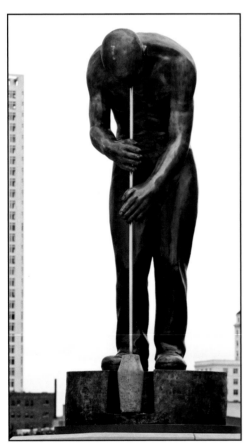

The finished sculpture.

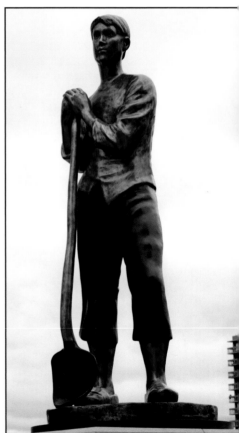

The finished sculpture.

LARGE-SCALE BRONZE SCULPTURES

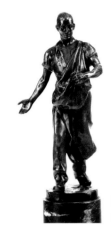

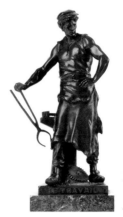

Max Valentin (German,
ca. 19th c.) *Field Worker*

Emile Louis Picault
(French, 1840-1915),
Master Forger

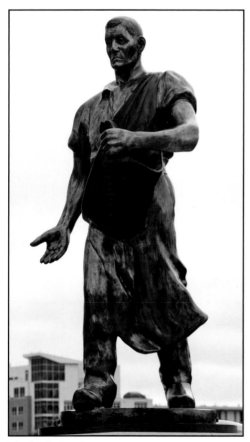

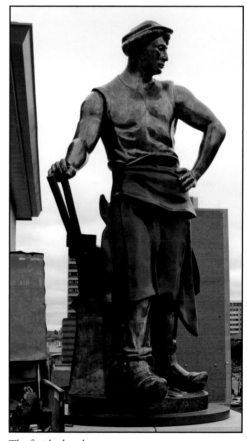

The finished sculpture.

The finished sculpture.

LIFE-SIZE BRONZE SCULPTURES

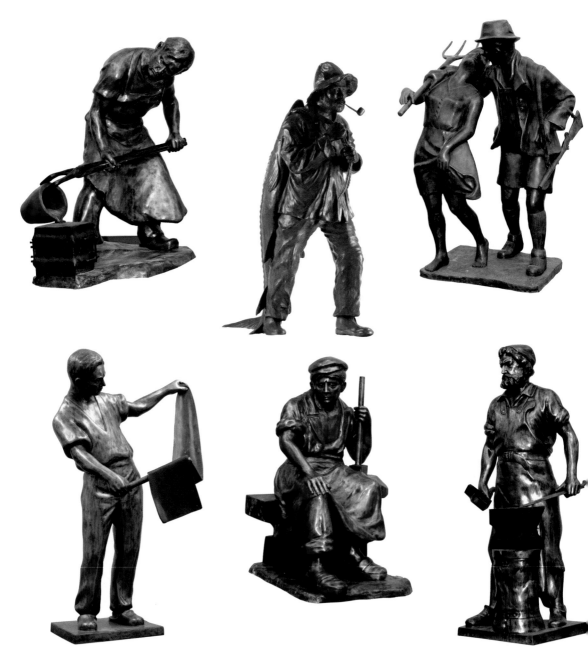

These six life-size sculptures appear in the rooftop garden.

SCULPTURE GARDEN

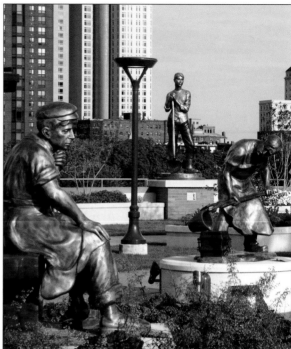

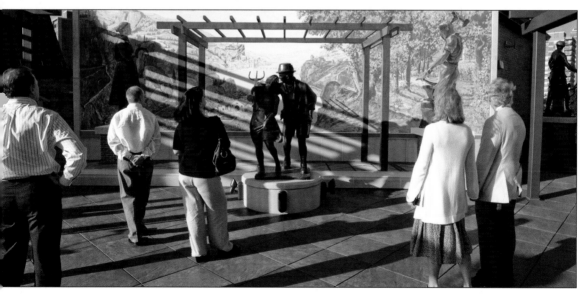

pend time amid the splendor of fine art and the backdrop of the Milwaukee skyline while also enjoying an environmentally friendly ooftop garden. Also, view the mural, *Allegory of Industry and Agriculture*, created by Hans Dieter Tylle.

SCULPTURE GARDEN

Inspired by Marten van Valckenborch's (Flemish, 1535-1612) *Fantastic River Landscape With Ironworks*, 1609, Hans Dieter Tylle created a very bright and light-flooded landscape painting to adorn a wall on the roof of the Grohmann Museum. Valckenborch's painting is one of the oldest in the *Man at Work* collection. The scenery Tylle painted in the mural reflects elements of the original painting but he used his own artistic interpretation using ideas from French Impressionism. Tylle also painted two bronze sculptures in a trompe-l'oeil foreground to make the viewer walk into the painting.

For this large-scale exterior project, Tylle used Keim mineral silicate paints from Germany. Murals painted in the 19th century with Keim have retained their original appearance to this day. The paint crystallizes into mineral substrates and will not fade, peel or blister.

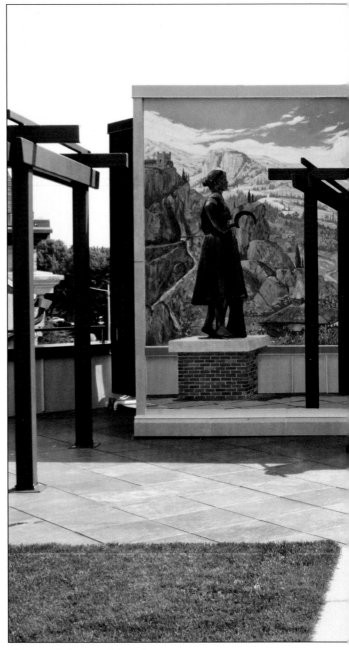

Allegory of Industry and Agriculture

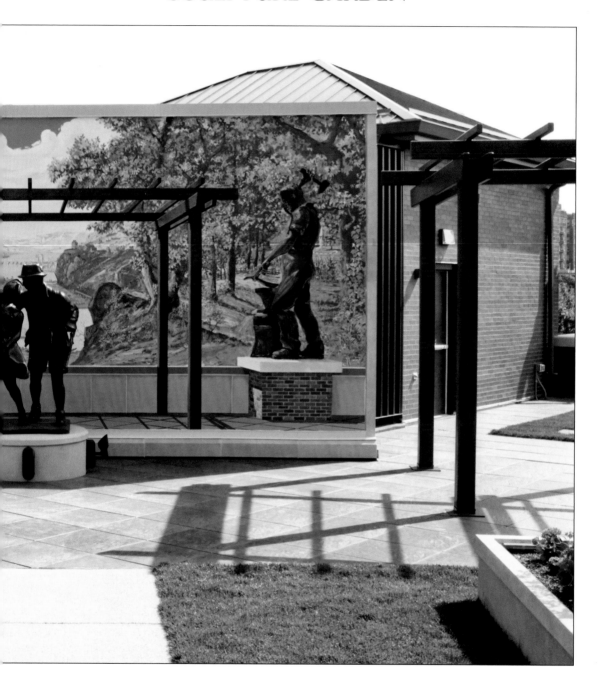

THE *MAN AT WORK* COLLECTION

The collection currently comprises more than 1,000 paintings and sculptures that span more than 400 years of history (ca. 1580 earliest-2007 latest). They reflect a variety of artistic styles and subjects that document the evolution of organized work, from manpower and horsepower to water, steam and electrical power. It was gifted to MSOE in 2001 by Milwaukee businessman and collector Dr. Eckhart Grohmann.

The earlier paintings depict forms of work, such as men and women working on the farm or at home. Later images show trades people engaged in their work, such as the blacksmith, chemist, cobbler, cork

Max Liebermann (German, 1847-1935) an oil painting composition that led to his renowned *Flax Barn in Laren* painting.

maker, glass blower and taxidermist. This includes a unique collection of approximately 30 17th century medical paintings depicting the primitive beginning of early medical treatments. The most recent works are images of machines and men embodying the paradoxes of industrialism of the mid-18th century to post-World War II. These works, often commissioned by the factory's owner, are views of steel mills and foundries surrounded by hefty train tracks or dark factory interiors where glowing molten metal is juxtaposed with factory workers and managers.

Most of the paintings are by German and Dutch artists, although others include American, Austrian, Belgian, Bohemian, Danish, Dutch, English, Hungarian, Flemish, French and Spanish.

Earliest work: ca. 1580 oil painting, *Venus at the Forge of Vulcan*, by a student of Italian painter Francesco Bassano [1559-1592].

Latest work: 2013 oil painting, *Commencement*, by German painter HD Tylle (b.1954).

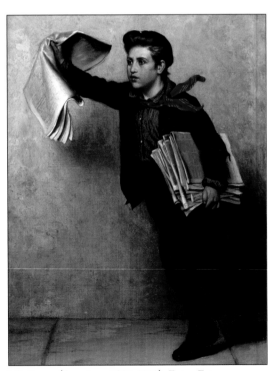

J.G. Brown (American, 1831-1913), *Extra, Extra (The Paper Boy)*, 1904.

THE *MAN AT WORK* COLLECTION

HIGHLIGHTS:

- Flemish painter Marten van Valckenborch (1535-1612), *River Valley with Iron Smelter*, ca.1600
- Dutch artist Pieter Brueghel the Younger (1564-1638), *The Peasant Lawyer*
- Dutch artist Jan Josefsz van Goyen (1596-1656), *A River Landscape with Lime-Kilns*
- German painter Ludwig Knaus (1829-1910), *Magician in the Barn*, 1862, *Potato Harvest*, 1879
- American painter J.G. Brown (1831-1913), *Extra, Extra (The Paper Boy)*, 1904
- German painter Max Liebermann (1847-1935), an oil painting that led to his renowned *Flax Barn in Laren* painting, now at the National Gallery in Berlin.
- French painter Julien Dupré (1851-1910), *Stacking Grain Sheaves*

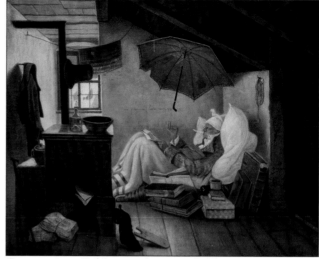
German painter Carl Spitzweg (1808-1885), *The Poor Poet*, 1837.

- German artist Erich Mercker (1891-1973). The collection includes over 80 by Mercker who, working in loose brushwork style, rendered colorful images of steel mills and foundries, bridge- and ship-building, quarries and interior views of factories.

- German painter Carl Spitzweg (1808-1885), *The Poor Poet*, 1837

- Bronze sculptures include: Longshoremen, farmers, miners, foundry workers and other laborers in the process of using the tools of their trades. Artists include Adrien-Etienne Gaudez, Gerhard Adolf Janensch, Constantin-Emile Meunier, Emile Louis Picault, and Americans Malcom Alexander, Max Kalish, Landon Lamb and Frederic Remington.

Dutch artist Pieter Brueghel the Younger (1564-1638), *The Peasant Lawyer*

RENOVATION AND HISTORY

One of the design challenges of the renovation project was to take advantage of the building's relatively small windows, which is ideal for displaying delicate artwork, while adding an element that would be inviting and intriguing to the public. In its last incarnation as a Federal Reserve Bank and not open to the public, the building's entries were secure and anonymous. Uihlein-Wilson architects replaced the corner of the building at Broadway and State Street with a glass cylindrical atrium that serves as a welcoming entrance and stairway, topped by an open metalwork dome.

FACILITY DETAILS

- Three floors, plus lower level and a rooftop sculpture garden
- Total space: 38,000 square feet
- Exhibition space: 15,120 square feet
- Height from lobby floor to dome top: 82 feet
- Lower level: vending cafe, workshop, classroom
- First floor: **iron and steel galleries**, docent library, gift shop, auditorium
- Second floor: **agriculture and construction galleries**, eight faculty offices, one classroom
- Third floor: **craftsmen and intellectual trades galleries**, eight faculty offices, one classroom
- Rooftop: sculpture garden, roof mural and stained glass windows

BUILDING HISTORY

The renovated, three-story, 38,000-square-foot concrete structure was built in 1924 as an automobile dealership that for many years was used by Metropolitan Cadillac, owned by Glenn Humphrey. In more recent times, the Federal Reserve Bank occupied the building until it ceased operation there in 2004.

PRIVATELY FUNDED

The museum is named in honor of Dr. Eckhart Grohmann, an MSOE Regent, Milwaukee businessman and avid art collector, who donated the art collection to MSOE in 2001 and subsequently the funds to purchase, renovate and operate the museum that bears his name. Dr. Grohmann and his wife, Ischi, are longtime supporters of scholarships for MSOE students and also donated funds to purchase the property for the Kern Center, MSOE's health and wellness facility.

PROJECT TEAM

Architect: Uihlein-Wilson Architects, Milwaukee
Construction: The Bentley Co., Milwaukee

TIMELINE

2001	*Man at Work* Art collection donated to MSOE
2005	MSOE purchased building with donated funds
September 2006	Demolition/Renovation began
October 2007	Grand Opening